# LEONARD
# COHEN
## A WOODCUT
## BIOGRAPHY

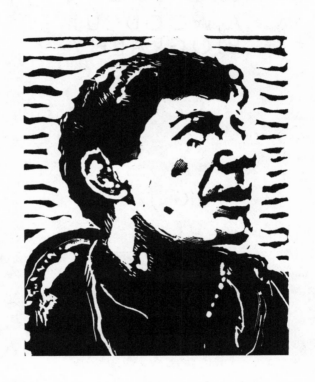

# LEONARD COHEN

## A WOODCUT BIOGRAPHY

A NARRATIVE HISTORY
IN EIGHTY-TWO
WOOD ENGRAVINGS

George A. Walker

FIREFLY BOOKS

# A FIREFLY BOOK

Published by Firefly Books Ltd., 2020
Text & Images © 2020 George A. Walker
Copyright © 2020 Firefly Books Ltd.

First printing

**Library of Congress Control Number:** 2020935147

**Library and Archives Canada Cataloguing in Publication**
Title: Leonard Cohen : a woodcut biography : a narrative history in eighty-two wood engravings / George A. Walker.
Other titles: Wordless Leonard Cohen songbook
Names: Walker, George A. (George Alexander), 1960- artist.
Description: Previously published under title: The wordless Leonard Cohen songbook: a biography in eighty wood engravings.
Identifiers: Canadiana 20200209515 | ISBN 9780228102885 (softcover)
Subjects: LCSH: Cohen, Leonard, 1934-2016—Comic books, strips, etc. | LCSH: Composers—Canada—Biography—Comic books, strips, etc. | LCSH: Wood-engraving, Canadian. | LCSH: Stories without words. | CSH: Authors, Canadian (English)—20th century—Biography—Comic books, strips, etc. | LCGFT: Graphic novels. | LCGFT: Wordless comics. | LCGFT: Biographical comics.
Classification: LCC PS8505.O22 Z95 2020 | DDC C811/.54—dc23

Published in Canada by
Firefly Books Ltd.
50 Staples Avenue, Unit 1
Richmond Hill, Ontario
L4B 0A7

Published in the United States by
Firefly Books (U.S.) Inc.
P.O. Box 1338, Ellicott Station
Buffalo, New York
14205

Printed in Canada

We acknowledge the financial support of the Government of Canada.

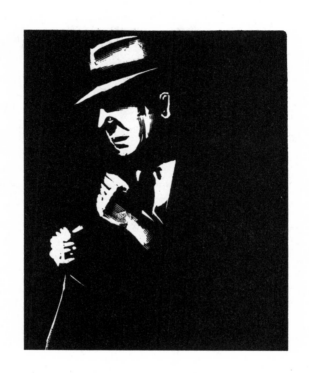

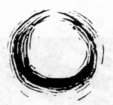

# LEONARD COHEN
## IN CELEBRATION OF 82 YEARS
### GEORGE A. WALKER

This book is a tribute to Leonard Cohen. This timeline of the life of Leonard Cohen does not follow a straight line. It jumps around years and decades like a cue ball seeking a target. It does follow a path from youth to old age, but sometimes takes a few steps back to jump forward. Like a dance! As Cohen says, "Dance me through the panic till I'm gathered safely in." These captions beside my engravings are just a guide to help you navigate the images and understand Cohen's life. I have not captured all the important people or moments in his life. Like the Enso on the opposite page, it's an imperfect circle.

I start with the young Leonard Cohen on his tricycle and end with an image of Cohen in a hospital bed. I took the last image from a story he told at a concert I attended. In the story he imagined himself at the end of his life smoking and being cared for by a young nurse. Many of the other images were inspired in part by Sylvie Simmons' biography, *I'm Your Man: The Life of Leonard Cohen* (2012). And, of course, I was influenced by Cohen's poems, song lyrics and two novels.

Cohen was a Zen Buddhist monk. The noble eightfold path to enlightenment is a significant teaching of the Buddha who described it as the way leading to the cessation of suffering (dukkha) and the achievement of self-awakening. The first step on the path is Right View and that is certainly part of the question I asked as I worked on these images: what is the right view of the life of Leonard Cohen and his influence on the popular culture that surrounds him?

I also wanted to play with the way the image of Leonard Cohen appears in pop culture. I sought to bring out the symbolism behind the number 8. I made 80 copies of an earlier hand-printed edition of this

book. In this edition I allowed myself 82 wood engravings to take the full measure of Cohen's 82 years of life.

I carved the wood blocks on the endgrain of Canadian maple, using the tools of the silversmith (gravers, spitstickers and scorpers). The blocks are technically wood engravings but most people do not differentiate between a woodcut and a wood engraving. If you are interested in differences in the processes and how I printed these engravings, I've explained it all in my book, *The Woodcut Artist's Handbook.* I've provided captions with this edition to better help the reader understand who they are looking at. Cohen was a complex man defined by his art and the people surrounding him.

Here are some details about the people who were important to Cohen and who therefore appear in these pages. The engraving on page 33 is a portrait of the Spanish poet Federico García Lorca (1898–1936), whose work Cohen loved so much that he named his daughter Lorca Cohen. The lyrics of "Take This Waltz" are derived from Lorca's poem "Pequeño Vals Vienés." The engraving on page 45 is of Kateri Tekakwitha, a seventeenth-century Algonquin-Mohawk saint who fascinated Cohen and is featured in his novel *Beautiful Losers.* I made a connection between Kateri and the number 8 by using her birth date, the 17th of April (1+7=8). Among many other people who enriched Cohen's life and whose lives were enriched in return, you'll find portraits of poets Irving Layton and Allan Ginsberg; publisher Jack McClelland; author Pierre Berton; singers Judy Collins, Joni Mitchell, Jimmy Hendrix, Janis Joplin, Lou Reed and Nico. There are portraits of artist Andy Warhol; songwriter / record producer Phil Spector; Marianne, Cohen's Hydra Island muse; and the two Suzannes in his life – Suzanne Elrod (his ex-wife), and Suzanne Verdal (the subject of his song). I could not include everyone in Cohen's life. I chose those I thought would make the most interesting engravings. My apologies if I left out someone important to you.

Cohen's compassion for others is seen in his music, novels, poetry and art. This deep empathy for others is one of the elements of his

work that has profoundly affected me. Famously, during a concert at a mental hospital, Cohen stopped to listen to a patient who was heckling. The man, who had a triangle missing from his skull, hollered, "Okay, big-time poet, big-time artist, you come in here, you've got the band with you, you've got the pretty girls with you, you're singing all these pretty words and everything, well what I want to know, buddy, is what do you think about me?" Cohen stopped playing, left the stage, walked over to the man, and began to hug him. There is an engraving of this event on page 105. To me, Cohen's action represents his compassion for the underdog as well as his genuine understanding of the inner struggles we all face. "Forget your perfect offering," Cohen observed. "There is a crack in everything. That's how the light gets in." Those words speak of hope within despair. When I make an engraving I am working from the darkness toward the light. Sometimes there is a crack in the block and I have to learn how I can incorporate it into the image — it's how the light gets in.

This book is a celebration, and I make no claims of knowing the man beyond what he has offered us through his words and music. Remember this verse from "Anthem":

> You can add up the parts
> but you won't have the sum

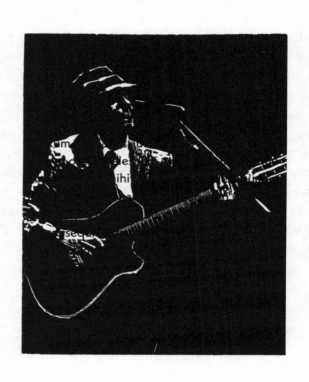

# LEONARD COHEN
## IMAGE, WORDS, MUSIC
### NORMAN RAVVIN

Some things in Montreal don't change. The roads break up in winter the way the St. Lawrence does in spring. The cross at the top of Mount Royal – placed there in 1924 – hangs like a white earring in the night-time sky, even as its mate, a smaller one installed by a 1930s premier, is stripped from the National Assembly by the new political status quo. The cross on the mountain has a surprising new competitor: an elderly Jewish man in a slanted fedora, painted on the side of an apartment building many stories high. He emanates a kind of full body halo. When viewed at night, his heart, hidden by an outstretched hand, bleeds red. Leonard Cohen. He's easily spotted from Sherbrooke Street down-town. But he's seen most strikingly from the Belvedere, the old lookout on one of the summits of Mount Royal. From here, you get a view of the city, spread green in summer, grey in winter, topped by the river, its bridges, and the American mountains in the far distance.

At the centre of that view there is Cohen, painted on his wall on Crescent Street, drawing the eye. The mural went up after his death, based upon a photograph taken by his daughter, Lorca. It is evocative of late-style Cohen, as he looked once he'd been resurrected as the kind of pop idol he'd never been in his early years as a poet, a novelist, and a songwriter. But his work had thrown up iconic possibilities before: the pair of intertwined hearts de-signed to imitate a star of David, which appeared on the cover of his most religiously-inclined volume of poetry, *Book of Mercy* and the evocation of the winged figure atop the sailor's church in Old Montreal, which haunts the stanzas of "Suzanne." Those were icons of his own making. The mural is something new, an image of Cohen so big he follows you as you walk downtown, as if he is an urban alternative to a harvest moon.

This book of images captures the nuance and texture of a transformative life and career. It finds its inspiration in images as various as the Crescent Street Cohen, footage unearthed in CBC and National Film Board archives, as well as little-remembered photographs from songbooks and documentary films. And it mines, too, the secrets of the written page, the hidden details of a creative life that celebrity and journalistic culture ignore. Though wordless, it is wickedly detailed in its willingness to trace Cohen's itinerant, unpredictable progress through life.

What do you see when you look at Leonard Cohen? He was a celebrity in the Internet age in part because of the variety of cover versions of his recent songs, but his career straddles a wide array of cultural milieus and creative venues. In France he joins the tradition of the *chansons*. In Poland his work contributed to an underground culture of resistance against the communist government. He began as a poet in the lyric mode, under the tutelage of Montreal modernists, publishing paeans to "his lady," whether she be Anne or Marita or Marianne. As early as 1958 he appeared on the CBC Radio program *Anthology*, setting his work to guitar accompaniment. In 1963 he published a Montreal-saturated *Bildungsroman*, the sweetly poetic first novel, *The Favourite Game*. Soon afterward he found an edgier voice, one more attuned to popular culture, European history and the legacy of colonialism, in his poetry volume *Flowers for Hitler* and in his great, provocative second novel, *Beautiful Losers*. The influential music executive John Hammond signed him to Columbia Records, linking Cohen's early output on such records as *Songs of Leonard Cohen* and *Songs from a Room*, with Columbia cohorts Bob Dylan, Benny Goodman, and Aretha Franklin.

These are some of the key shifts he made: Montreal to New York; poetry to fiction to song; cosmopolitan Jewish urban culture to the discipline of Zen. At certain points in his career, Cohen published works that found only a small, yet devoted audience. These include the hard-edged collection *The Energy of Slaves* and the diffident, self-reflexive

*Death of a Lady's Man.* These lurk, still, gems hidden by the wave of adulation offered at live concerts and by the growing list of performers who cover Cohen's songs.

*Leonard Cohen: A Woodcut Biography* should be "read" to music: Frankie Laine singing "Jezebel;" Ray Charles singing "Somebody said lift that bale" from "Ol' Man River;" the haunting Yom Kippur liturgical refrain, "Who by Fire;" Marvin Gaye's "It Hurt Me Too." These make up the wordless songbook's soundtrack.

Cohen's words on the page, typed on a portable manual typewriter or scribbled in Sharpie pen in a notebook, are the unseen subtitles for certain images. The nylon string acoustic and later a black electric guitar take over as the iconic tools of the trade. Blackening the page gives way to bar chords, smart inversions of the blues and country swing. If one looks carefully at the chords pictured here, they are almost legible, a kind of visual guide to early songs and their often melancholy chords: F minor, D minor, and the little-appreciated B flat.

Images of Cohen in late career often have adoration as their subject, whether in their setting – the ever-prevalent sold-out show – or in the tone of appreciation for the last creative man standing, the elder whose songs have been picked up by younger generations of performers for their elegance, their dark romance, their idiosyncrasy, their poetic simplicity. Musicians, like readers before them, feel that Cohen is speaking to them.

Images from early years have more commonplace subjects: the rich kid on a tricycle in a home movie. Or they are solitary: the poet at a humble table, listening to jazz on a transistor radio, in a carefully chosen, seedy hotel room. Or they are intimate: the glowing appreciation shared between such workers in song as Cohen and Judy Collins. Or they are strange, even mythical: the once-brilliant, gone-crazy Phil Spector holding a gun to Cohen's head in a bizarre expression of admiration, Hollywood-style.

Radios. Oldsmobiles. Window blinds. Coffee cups of the kind once found in coffee shops. Airport waiting rooms. Small children reading.

These are the nearly secret, neglected accoutrements of the poet's, the novelist's, the songwriter's most average afternoon. Some of these are sharply drawn in Cohen's own work. Here is a vivid tableau laid out in *Flowers for Hitler*: "Albert Hotel sixth floor seven thirty p.m. On the scratched table I set out in a row a copper bust of Stalin, a plaster of paris bust of Beethoven, a china jug shaped like Winston Churchill's head, a reproduction of a fragment of the True Cross, a small idol, a photograph of a drawing of the Indian Chief Pontiac, hair, an applicator used for artificial insemination. I undressed and waited for power." In the liner notes of "Leonard Cohen: The Best Of," Cohen introduces "Sisters of Mercy" with cinematic flair: "This was written in a few hours one winter night in a hotel room in Edmonton, Alberta. Barbara and Lorraine were sleeping on the couch. The room was filled with moonlight reflected off the ice of the North Saskatchewan River."

This woodcut songbook brings such things into relief, alongside the more iconic, public face that may well be headed for the odd status of sainthood acquired upon being pictured on a postage stamp, where one also finds mountain peaks, rocket ships, favoured animals, and locomotives.

An astounding artifact of Cohen's life in pictures was captured in a CBC TV interview he gave after the release of *Beautiful Losers*. The interviewer is a very young Adrienne Clarkson with an elaborate beehive hairdo, while Cohen wears a short, sharply tailored jacket suitable for an early Rolling Stones photo shoot. The television camera style of the day calls for long close-ups and both Cohen and his interviewer have profiles the camera likes. Clarkson takes the parents' point of view and teases Cohen about his many pursuits, his interest in drugs and the cultural revolution. Cohen keeps his cool until late in the discussion when he tells Clarkson, "I think, in a way, there's a war on." At this point, early in his career, even before gaining fame as a songwriter in America, Cohen's outlook and style are contrary to the CBC's authoritative voice, its position as an arbiter of taste in Canada. With his telegenic face and modulated tone, he presents an ambiguous threat to the old order.

At this youthful stage, Cohen's life in images is one of struggle. He must maintain his cool while the voice of authority asks, "What's the point of writing poetry?" With time, the camera and the person wielding it will become more cordial: Cohen in his house, playing a recording of something not yet released for his friend, the poet Irving Layton; recent images of Cohen being feted, whether by songwriters and performers or by the government of Canada. The more reverential the image, the more narrowly focused its message.

Many of the images in this wordless songbook point beyond themselves; they carry with them multiple echoes and resonances, like the strummed strings of a guitar. Each might open into its own little movie, picturing a particular moment in a particular place, with a characteristic motive and mood. The more we know about Cohen, the further into the dark space surrounding the image we can push, the likelier it is that we will expand the image to include a poem, a song, a streetscape, or a humble hotel room. In this way the images are scenarios for the wordless reader, a set of possibilities on the way to the next stage in Cohen's reception.

These images are, more simply, invitations to know more. Cowboy hats? Coca-Cola? Lou Reed? Constantine Cavafy? A serious yet alluring face framed by dark hair. A monk's habit. The slanted fedora of Frank Sinatra's youthful profile.

Look. Slowly. With the room arranged and the music just so. Cohen's words will come rushing at you, almost too many at once.

**Norman Ravvin** lives in Montreal, where he writes and teaches. His novels include *The Girl Who Stole Everything, The Joyful Child* and *Lola by Night*, which takes place in part at the Chelsea Hotel. His non-fiction, including an essay on Kateri Tekakwitha in his *Hidden Canada: An Intimate Travelogue*, has addressed Leonard Cohen's work. He is also the author of the story collection *Sex, Skyscrapers, and Standard Yiddish* and co-editor of *Failure's Opposite: Listening to A.M. Klein*.

# LEONARD COHEN
## A NARRATIVE HISTORY IN
## 82 WOOD ENGRAVINGS

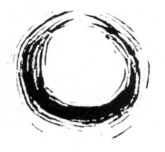

Five year old Leonard Cohen on his tricycle in
Westmount, Montreal in the late 1930s.

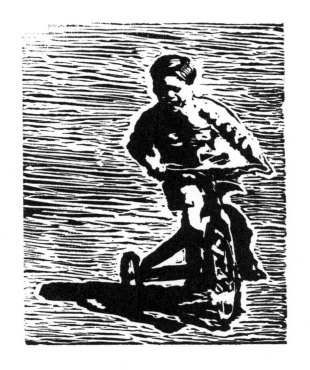

Nathan Bernard Cohen (1891–1944), Leonard's father. He owned a clothing store and died when Cohen was 9.

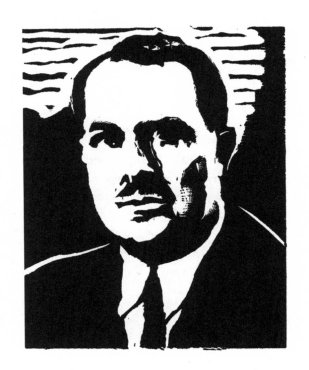

Masha Cohen (1905–1978), Leonard's mother. She had a very close relationship with her son. Here they are in the living room of their Montreal home in 1944.

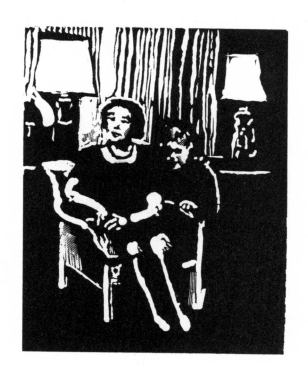

Fascinated with a book on hypnotism, *25 Lessons in Hypnotism: How to Become an Expert Operator* (M. Young, 1899), Leonard Cohen mesmerized the family maid and instructed her to undress.

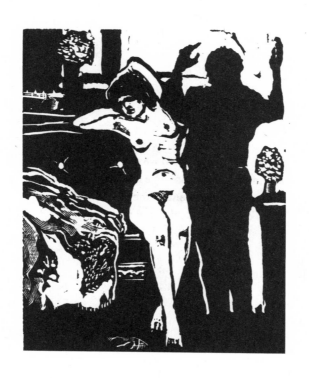

When Leonard Cohen was 18 years old he had aspirations of becoming a country and western singer. In 1952 he and some friends started a band called The Buckskin Boys.

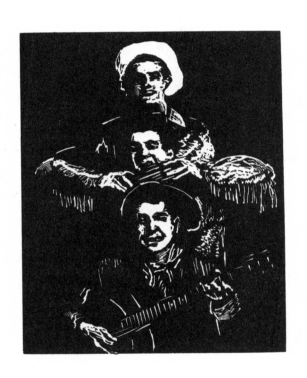

The Buckskin Boys was an all Jewish country and western band that played songs like "Red River Valley" and "Turkey in the Straw."

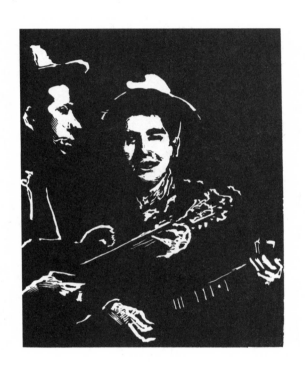

Leonard Cohen attended McGill University in Montreal from 1951–1955. In his third year he met professor Louis Dudek (1918–2001) who taught him literature and inspired him to become a poet. Much later they had a falling out when Dudek called Cohen's writing a "rag-bag of classical mythology."

Federico García Lorca (1898–1936). Leonard Cohen discovered Lorca's poetry in the 1950s and it became a significant influence on his writing. He said that Lorca's words were, "a landscape that you thought you alone walked on."

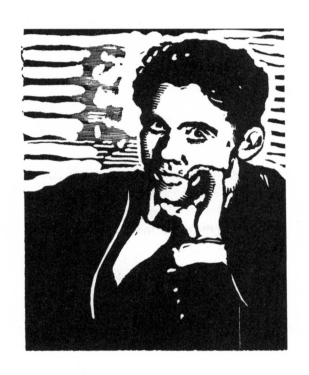

Pierre Berton (1920–2004) interviewed
Leonard Cohen and Irving Layton (1912–2006)
for the *Pierre Berton Show* on CBC TV, Montreal
in 1964. In the interview, Layton and Cohen
talked about the role of the poet in society.

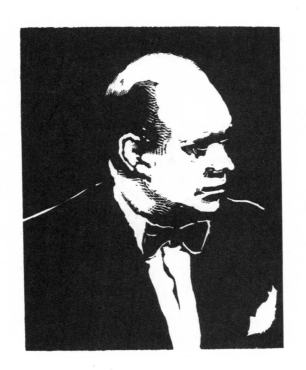

During the interview, Pierre Berton asked the 30-year-old poet if he cared or was bothered about anything. Cohen replied, "Well, I'm bothered when I get up in the morning. My real concern is to discover whether or not I'm in a state of grace. And if I make that investigation, and discover that I'm not in the state of grace, I'm better in bed."

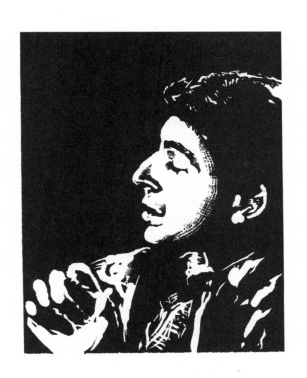

Adrienne Clarkson (b. 1939), host of the talk show *Take 30,* on CBC-TV, interviewed Leonard Cohen in 1966. She asked him about his work as a poet and songwriter. Cohen said, "I'm not interested in an insurance plan for my work."

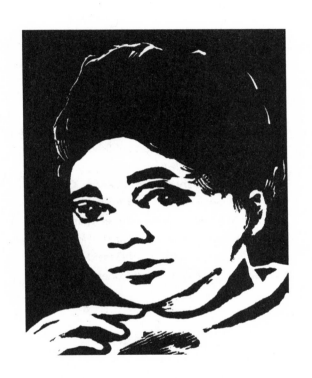

Leonard Cohen with his publisher, Jack McClelland (1922–2004) and friend Irving Layton (1912–2006). In 1961 McClelland & Stewart published the 27 year old poet's second collection of poetry, *Spice-Box of Earth,* to great literary acclaim in Canada. Cohen's third poetry book was released in 1964 but not until Jack McClelland insisted Cohen change the orignal title from *Opium and Hitler* to *Flowers for Hitler.* Micheal Ondaatje (b. 1943) said that Jack McClelland was uncertain that Cohen was a genius.

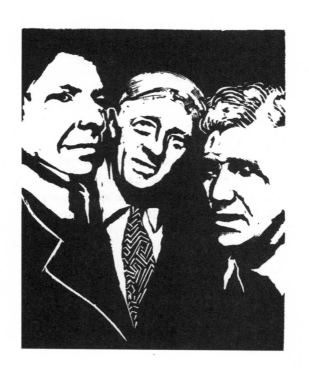

Irving Layton was a poet and close friend of Leonard Cohen. They met at McGill in 1954 and, despite their age difference and opposing character traits, remained friends for life.

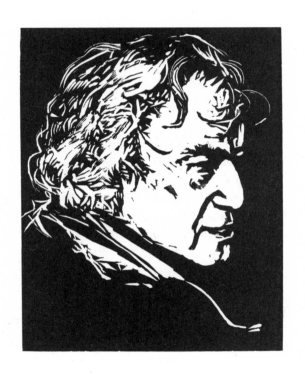

Saint Catherine Tekakwitha (1656–1680) was a 17th-century Mohawk who was canonized by the Roman Catholic Church. She is one of the characters in Cohen's 1966 novel, *Beautiful Losers*. The book is credited with introducing postmodernism in Canadian literature.

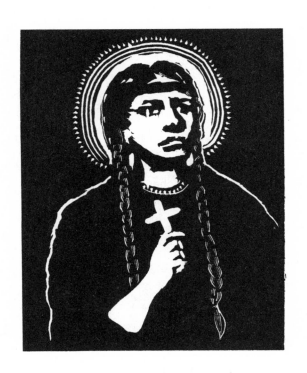

The young Leonard Cohen reciting poetry to an audience in 1966. Cohen grew up in the Jewish liturgical tradition and read his poems to his audience as if he was reading prayers.

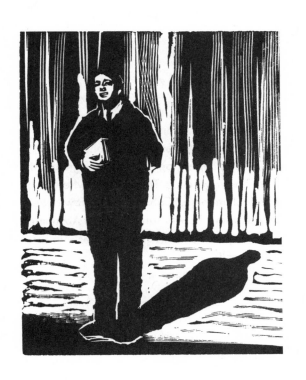

Rabbi Solomon Klonitzki-Kline (1868–1958),
Leonard Cohen's grandfather. Cohen's book,
*A Ballad of Lepers*, opens with, "My grandfather
came to live with me. There was nowhere
else for him to go." Cohen liked to sit with his
grandfather who was suffering from Alzheimer's
and was proud that his grandson was a writer
like himself.

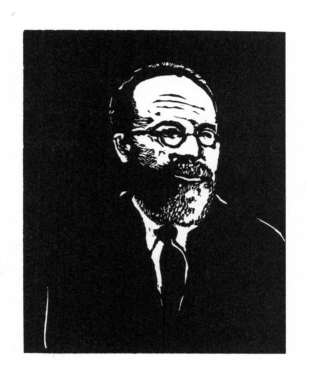

Leonard Cohen at a poetry reading in New York. In his 1963 book, *The Favorite Game,* Cohen's protagonist says, "Poetry is a verdict, not an occupation."

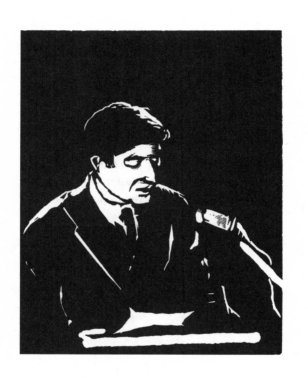

Leonard Cohen checked into a cheap hotel in Montreal to find a sanctuary. He worked on his poems while listening to the radio and having a bath.

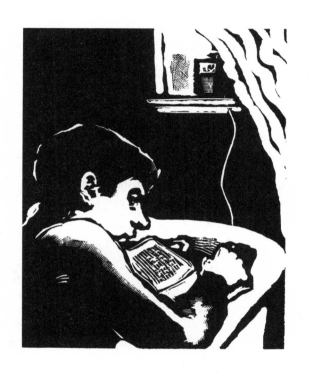

Leonard Cohen getting a haircut before a television appearance.

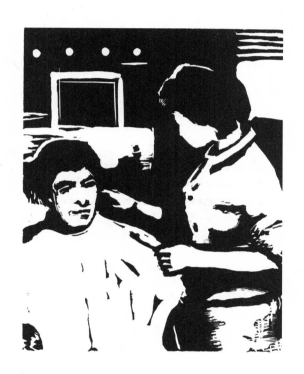

At 32, Leonard Cohen published his second and final novel, *Beautiful Losers.* In the book he wrote, "Do not weep. I will not die now. I will dream my cure."

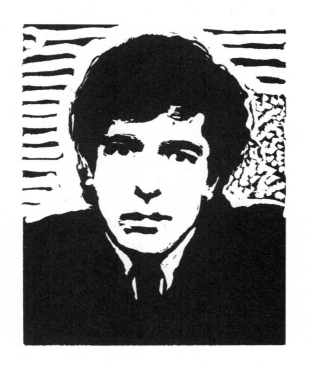

Leonard Cohen hosted parties at his flat in Montreal where he shared his poetry over drinks and music.

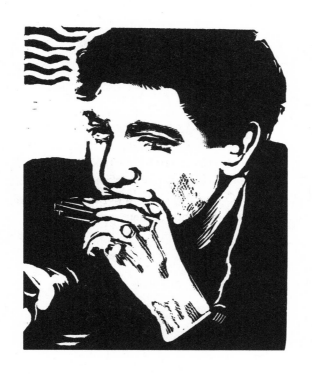

This image was inspired by the 1965 documentary, *Ladies and Gentlemen... Mr. Leonard Cohen* that showed Cohen getting together with friends to share some fun.

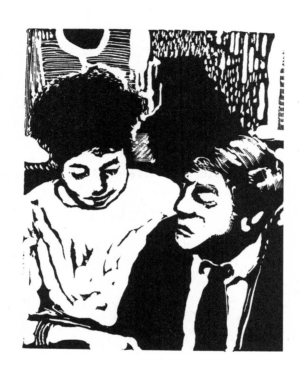

Judy Collins (b. 1939) was a friend of Cohen and her cover of his song "Suzanne" helped introduced the world to Leonard Cohen.

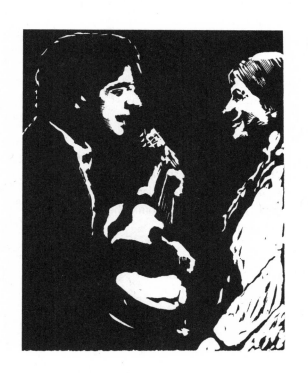

This is my image for the song, "Suzanne".
I thought of the big ships on the St. Lawrence,
tea and oranges and the dancer Suzanne
Verdal (b. 1944) with whom Cohen had a
platonic love affair.

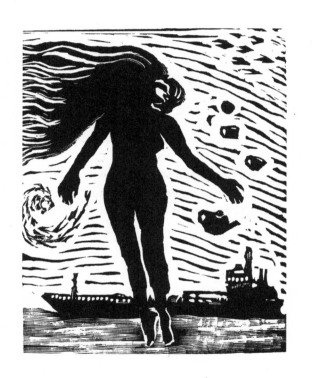

Leonard Cohen and Marianne Ihlen
(1935–2016) returned to his place in
Hydra, Greece in the early 1960s.

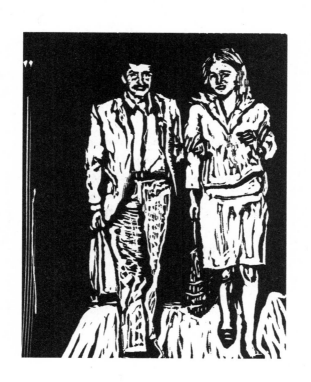

Marianne was already married when she met Cohen. The marriage was troubled and Marianne and Leonard spent many days walking on the beach in Hydra together. He wrote in a letter to her in 1963, "I could never have rewritten my book without you, and I don't think I'll write another one without you."

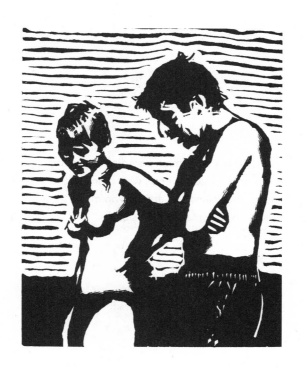

Hydra was a bohemian paradise for Leonard Cohen. He made friends with many of the poets, musicians and artists who made their home on the small Greek island.

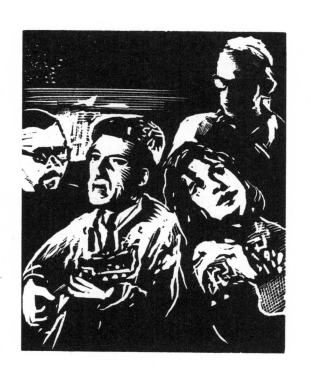

Leonard Cohen travelled to Cuba in 1961. The trip inspired his poem, *The only tourist in Havana*. He did not meet Fidel Castro (1926–2016) until decades later.

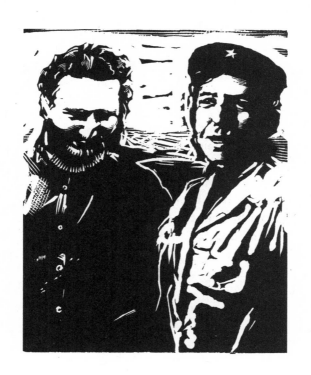

Leonard Cohen wrote about his routine on Hydra," I get up around 7 generally and work till about noon. Early morning is coolest and therefore best, but I love the heat anyhow, especially when the Aegean Sea is 10 minutes from my door."

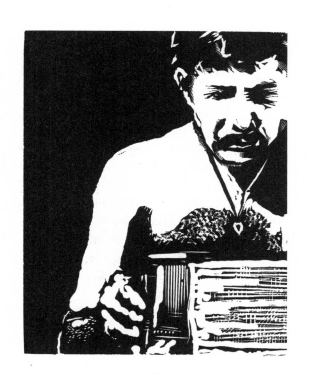

Marianne Ihlen (1935–2016) was Leonard Cohen's lover while he was living on Hydra. They remained friends after their breakup in 1967 and the song, "So Long, Marianne" is about her. Cohen sent her an email when he was dying of leukemia, "And you know that I've always loved you for your beauty and your wisdom, but I don't need to say anything more about that because you know all about that. But now, I just want to wish you a very good journey. Goodbye old friend. Endless love, see you down the road."

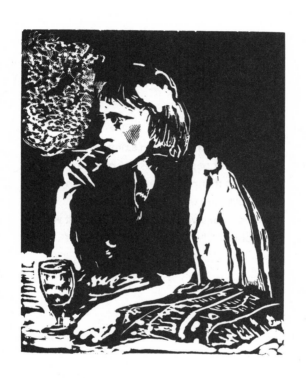

Leonard Cohen in 1967. In an interview with the UBC student paper, *Ubyssey* Cohen explained, "The thing that people are interested in doing now is blowing their heads off and that's why the writing of schizophrenics like myself will be important."

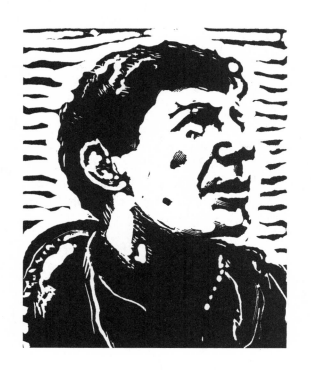

Leonard Cohen hung out with with Andy Warhol (1928–1987) and his cohorts at Warhol's New York studio known as *The Factory* in 1967. Cohen's debut album, *Songs of Leonard Cohen*, was released in that year.

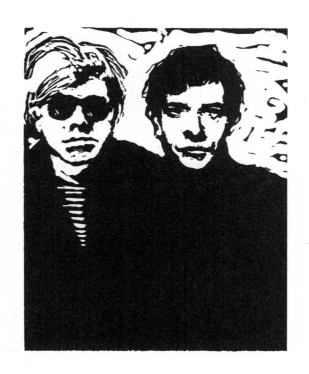

During the 1960s Leonard Cohen lived  in the Chelsea Hotel in New York and hung out with musicians like Bob Dylan (b. 1941), Janis Joplin (1943–1970) and Jimi Hendrix (1942–1970).

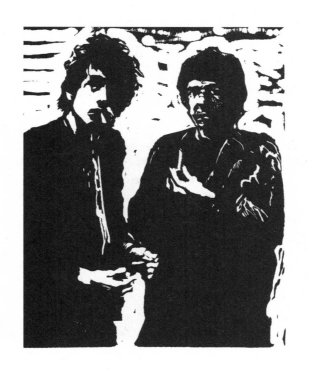

Janis Joplin also lived at the Chelsea Hotel. Cohen met her in the elevator in 1968.

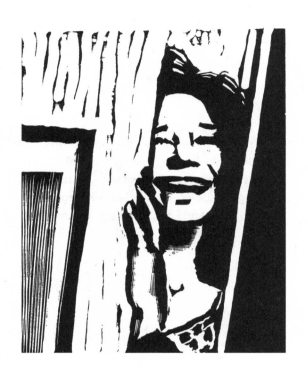

Leonard Cohen wrote about his relationship with Janis Joplin in the song, "Chelsea Hotel #1 " and once said, "I had heard about the Chelsea Hotel as being a place where I might meet people of my own kind. And I did. It was a grand, mad place."

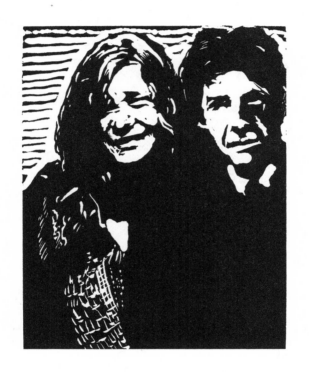

Leonard Cohen met Jimi Hendrix (1942–1970) while he was dating Joni Mitchell (b. 1943).

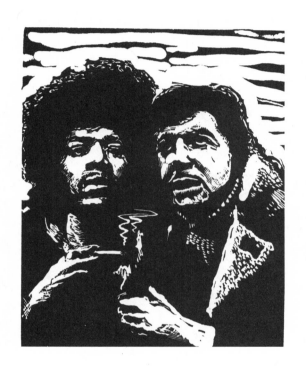

Leonard Cohen dated Joni Mitchell (b. 1943)
for a few months in 1967 and 1968.

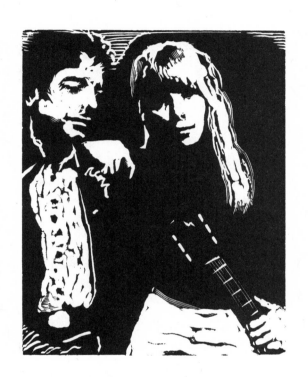

The song "Rainy Night House" is Joni Mitchell's farewell to Leonard Cohen. Rumour was that Joni was easy to love but had a turbulent personality.

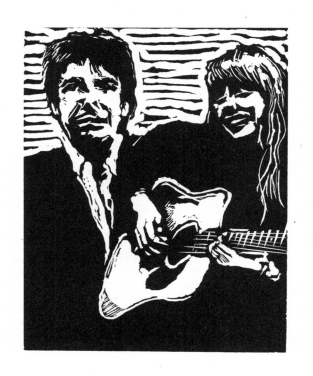

Lou Reed (1942–2013) and Leonard Cohen in New York. Reed introduced Cohen to Andy Warhol and Nico (1938–1988).

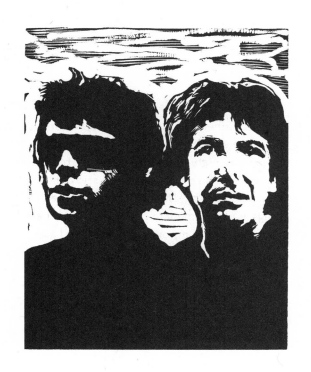

Leonard Cohen and the singer Nico, whose real name was Christa Päffgen (1938–1988). Cohen was infatuated with her beauty, but she rebuffed his advances. Cohen said of her in *Book of Longing*, "My work, among other things, is a monument to Nico's eyes. That there was such a pair in my own time, and that I met them, forehead to forehead; ...and it was her."

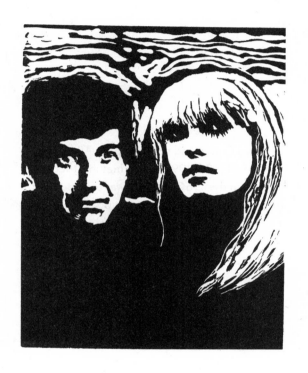

Leonard Cohen and the beat poet Allen Ginsberg (1926–1997). They met in Athens, Greece in the 1960s. Cohen was too young to be a beat and too old to be a hippie.

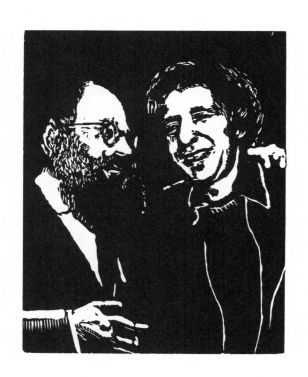

Leonard Cohen always carried notebooks and scribbled ideas down wherever he went.

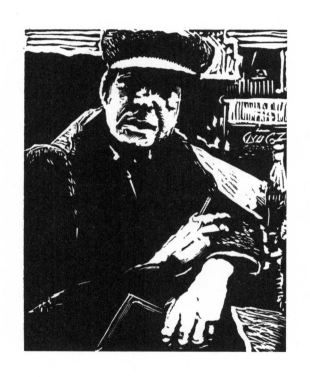

Leonard Cohen made five record albums and wrote seven books of poetry as well as two novels between the 1960s and 1980s.

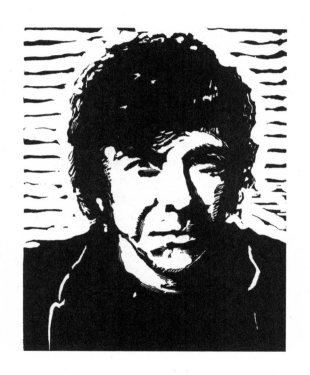

In the 1970s Leonard Cohen decided he wanted to perform at mental asylums. At one show a man with a triangle cut into his skull heckled Cohen and demanded to know what Cohen thought of him. Cohen left the stage and took him in his arms and hugged him.

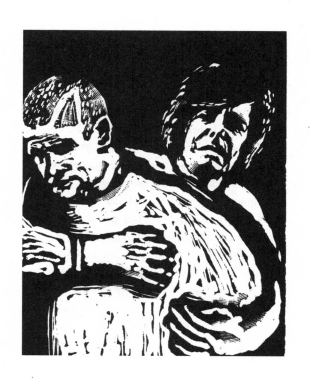

The public thought of Leonard Cohen as a ladies' man. In reality I think he thought Venus was playing with his head — although he did sincerely worship women at the altar of Venus. In his book, *Beautiful Losers* he wrote, "I have let women lead me anywhere, and I am not sorry. Convents, kitchens, perfumed telephone booths, poetry courses — I followed women anywhere. I followed women into Parliament because I know how they love power."

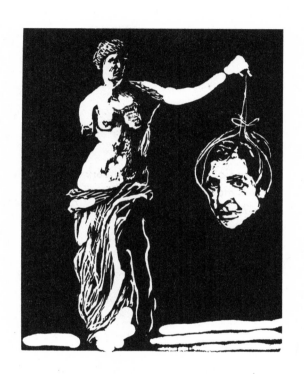

Leonard Cohen in 1978. In February of 1978 Cohen's mother died. He dedicated his new book, *Death of a Lady's Man* to her memory.

Leonard Cohen saw all women as goddesses. In his book *Beautiful Losers* he wrote, "I follow women into the world, because I loved the world."

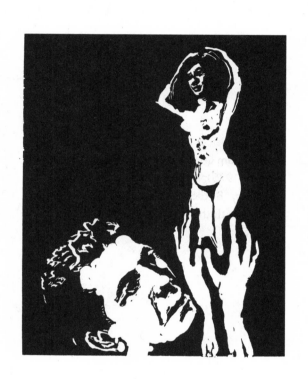

In his album liner notes to *The Best of Leonard Cohen* (1975), he wrote about performing the song, "Bird on a Wire": "I always begin my concert with this song. It seems to return me to my duties."

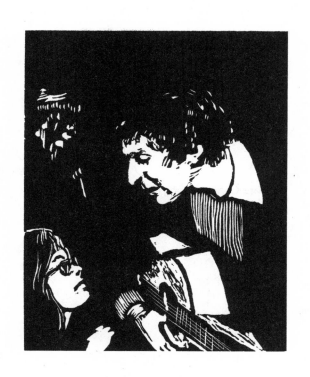

Leonard Cohen playing his acoustic guitar in 1980.

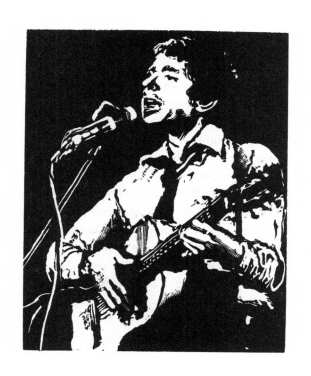

In 1993, Cohen had an interview with *Song Talk* magazine. Cohen explained how his song, "Bird on a Wire" came to be: "It was begun in Greece because there were no wires on the island where I was living to a certain moment. ... but when they first went up, it was about all I did – stare out the window at these telephone wires and think how civilization had caught up with me and I wasn't going to be able to escape after all. I wasn't going to be able to live this 11th-century life that I thought I had found for myself. So that was the beginning."

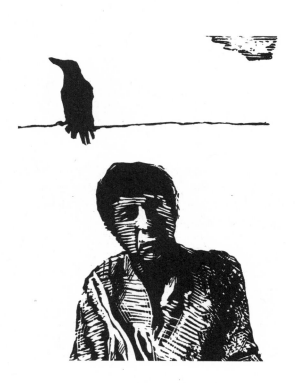

Cohen released his fourth album, *New Skin for the Old Ceremony,* in 1974. One song on this album, *Take This Longing,* illustrates Cohen's desire for a woman's love.

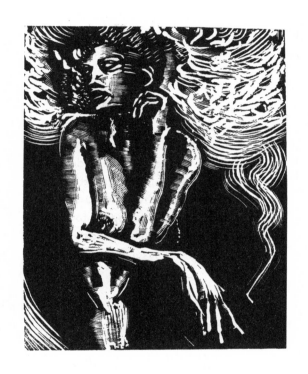

In his pursuit of a higher spiritual and mental plane, Leonard Cohen experimented with LSD, amphetamines and other drugs during his concerts. He asked his friend Mort Rosengarten (b. 1933) to make him a mask to use on stage during his European tour. A mask, like drugs, is something to hide yourself behind. The mask was never used on stage.

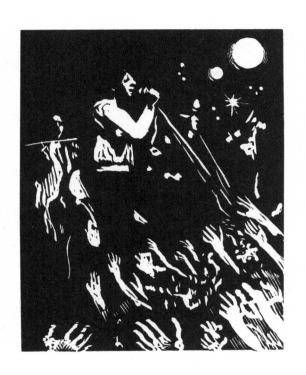

Some of the public thought that Cohen had a mental disorder and was suffering from depression. His troubles were probably associated with working long hours without sleep and taking large amounts of amphetamine, topped up with LSD.

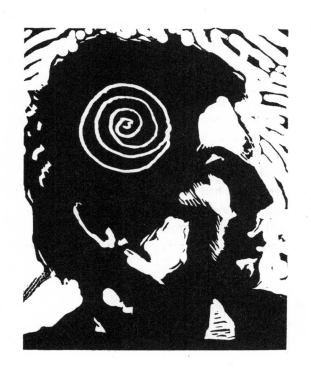

Leonard Cohen often read to his children Lorca and Adam. As a grandson of a rabbi he felt that he had a duty to teach, counsel and read to his children. Years later when his 18-year-old son, Adam, had been in a serious car accident, Leonard stayed by his bedside reading to him in the hospital for months until the boy awoke from his coma and politely asked, "Dad, can you read something else?"

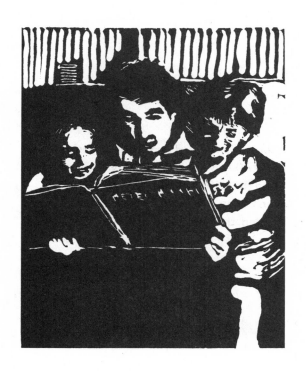

Leonard Cohen had two children, Lorca (b. 1974) and Adam (b. 1972), with Suzanne Elrod (b. 1959), who was 15 years younger than Cohen. Although they were never legally married, they separated in 1979.

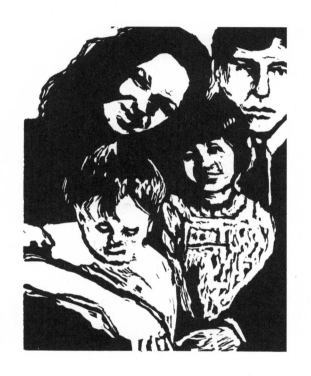

Leonard Cohen left Suzanne Elrod and his son to perform for the troops in Israel during the 1973 Yom Kippur war. After he returned home Suzanne became pregnant with their daughter, Lorca.

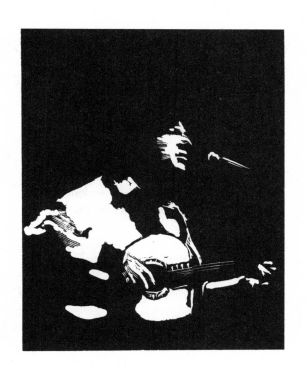

Cohen taking a smoke break at the Gold Star recording studios in 1977 while working on the *Death of a Ladies' Man* album with Phil Spector.

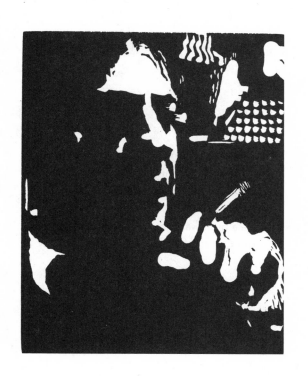

Phil Spector (b. 1939) with Cohen. Spector's "wall of sound" technique was a vastly different sound for Cohen. The album *Death of a Ladies' Man* marks a shift that Cohen wasn't happy with and the album was met with bad reviews from the critics.

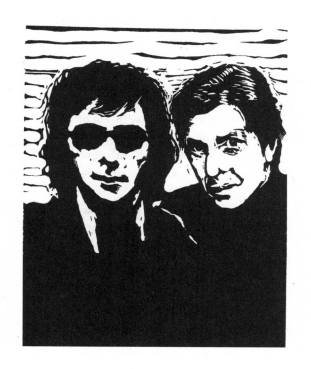

Spector was scary to work with. He often brought wine and guns to the recording studio. Spector's obsession with guns would land him in jail in 2009 for the murder of Lana Clarkson. She was found in his apartment shot in the head by a handgun. It was noted at his trial that Spector had a penchant for waving guns in people's faces.

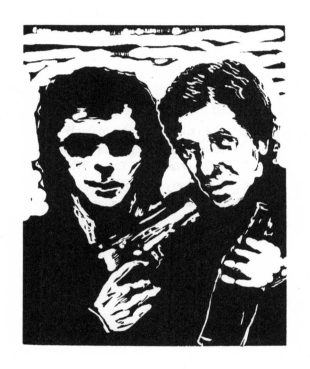

Leonard Cohen told Janet Maslin (b. 1949) about recording with Spector in a November, 1977 issue of *The New York Times*. "The music in some places is very powerful but, by and large, I think it's too loud, too aggressive. The arrangements got in my way. I wasn't able to convey the meaning of the songs."

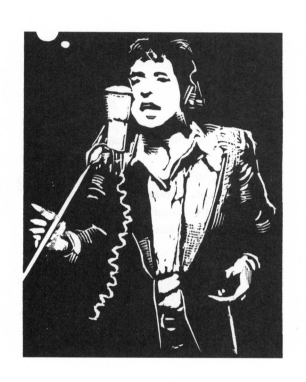

Leonard Cohen with his Zen master guide, Joshu Sasaki (1907–2014). Cohen would later become an ordained Rinzai Zen master himself. The Enso symbol above Joshu Sasaki's head is sometimes referred to as the circle of enlightenment. It is an imperfect circle, as is the experience of living.

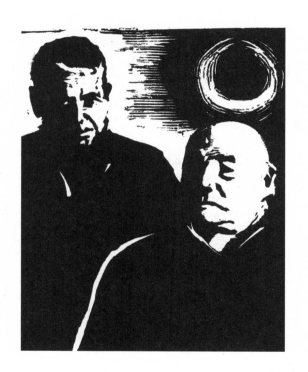

Leonard Cohen had his first brush with Zen Buddhism in the 1960s and 1970s. He continued to be interested in Eastern thought and ritual throughout his life.

Leonard Cohen would wake at 4:30 in the morning to go to the Zen Centre to practice his meditation. He was ordained a Rinzai Zen Buddhist monk in 1996 and took the Dharma name Jikan, meaning "silence."

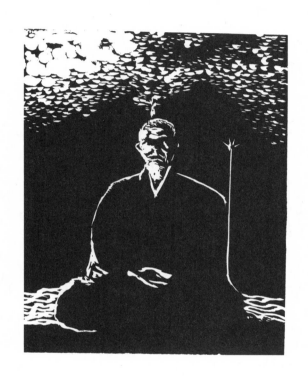

Leonard Cohen wrote "Take This Waltz" in Paris in 1986. It was Leonard's adaption of a Frederico Garcia Lorca (1898–1936) poem to mark the anniversary of the poet's death.

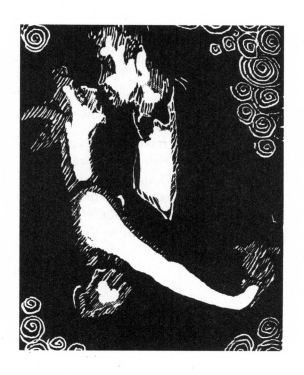

In 2013, while doing research for this book,
I met the bookseller Hannelore Heinemann
Headley (1936–2013). She had met Leonard
Cohen who frequented her bookstore when
she was in Montreal in the 1960s. When I asked
what he was like, she told me he "smoldered."

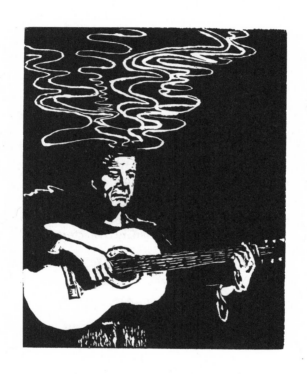

In the 1980s Leonard Cohen made the film, *I Am a Hotel,* for the CBC in which he is seen smoking and watching the hotel guests at the King Edward Hotel in Toronto. The film had no dialogue but used Cohen's songs to comment on the actions of the imaginary characters.

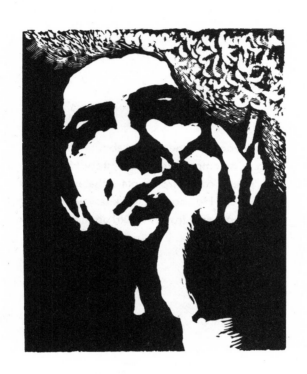

When Leonard Cohen spoke about his creative process, he emphasized the mystery. He said "poetry comes from a place that no one commands." He also said, "If I knew where the good songs came from, I would go there more often."

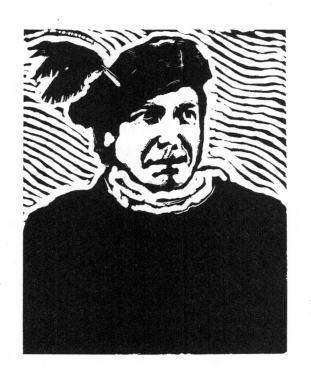

Leonard Cohen was forced to go back on tour in 2008 to replenish his bank account. His former lover, Kelley Lynch (b. 1957), and the investment financier Neal Greenberg (b. 1956) had managed to lose most of Cohen's savings through bad investments. The tour would restore his lost funds and set him back on the road to popularity.

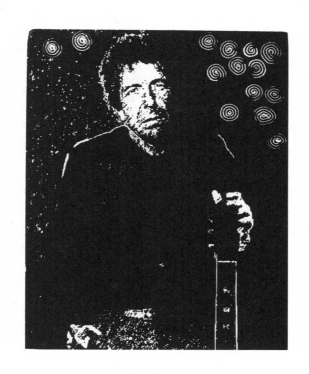

Leonard Cohen, Perla Batalla (b. 1963) and Julie Christensen (b. 1956) singing the song, "Anthem." The song is from Cohen's album titled, *The Future*. The album was met with critical acclaim. In 1992, the wall came down in Berlin, marking a turbulent time that was expressed in Cohen's music with a flicker of hope. In the song "Anthem" Cohen sings the lines, "There is a crack in everything, that's how the light gets in." This reminds me of the process I use to create these woodcuts. I work from a black background engraving my way to the light and sometimes a crack may appear.

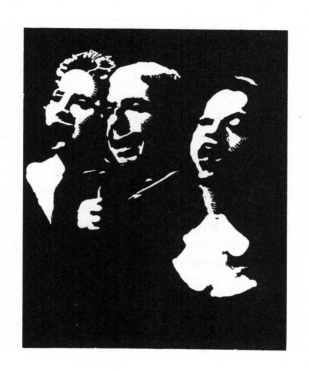

Leonard Cohen's music was sometimes a struggle for him. He commented to Sylvie Simmons, "There's one song that I've been working on for many, many years — decades... So, that's what my work is right now and that's what I think about. My mind is not given to philosophy, it's given to a kind of prayer. A kind of work. But it's mostly about the problem of getting back to the key I started off in."

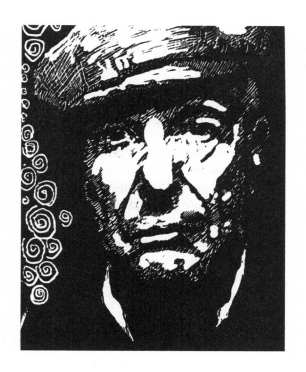

Leonard Cohen was engaged to the actress Rebecca De Mornay (b. 1959) in the 1990s. She was a co-producer on his 1992 album, *The Future*. Cohen dedicated this album to her with an inscription that quotes Rebecca's coming to the well from the Chapter 24 of the Book of Genesis. This image was inspired from a photo of Cohen and De Mornay at the 64th Annual Academy Awards.

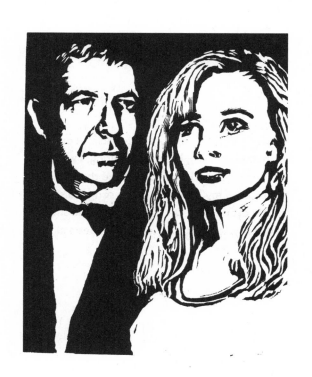

In his song, "Waiting for the Miracle", Leonard Cohen says "Baby, I've been waiting, I've been waiting night and day, I didn't see the time, I waited half my life away..." The song is also a subtle proposal to De Mornay when he sings, "Ah, baby, let's get married, we've been alone too long."

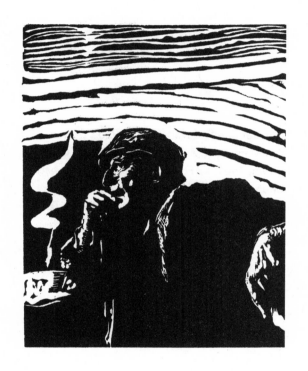

Constantine P. Cavafy (1863–1933). Cohen based his song "Alexandra Leaving" on Cavafy's poem, *The God Forsakes Antony*. Cohen had been working on the song since 1985 but it wasn't released until 2001 on his album, *Ten New Songs*.

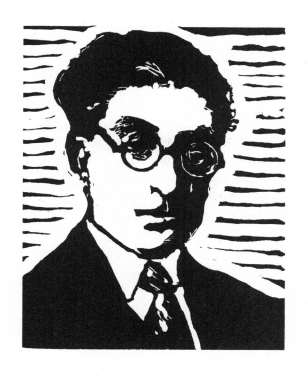

Sharon Robinson (b. 1958). Robinson worked for Cohen as his backup singer and was a co-writer, arranger and performer on every track on *Ten New Songs*. They worked together for 37 years.

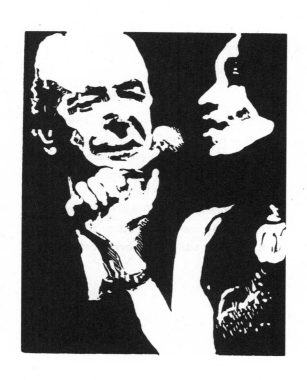

Cohen was made an Officer of the Order of Canada in 1991 and in 2003 Governor-General Adrienne Clarkson made him a Companion of the Order of Canada. This award is the highest honour of merit that can be awarded in Canada. It was established in 1967, during Canada's centennial celebrations to recognize those who have made Canada or the world a better place.

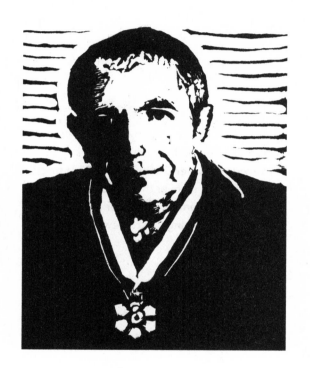

Leonard Cohen performed 387 shows worldwide between 2008 and 2013. At first it was an effort to recover the money he lost in 2008, but it became a major marker in Cohen's long career, rocketing him to new fame.

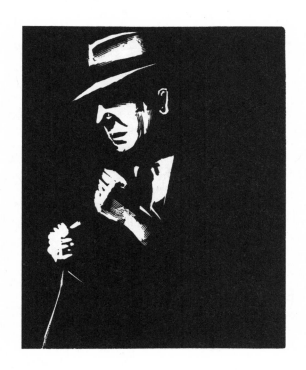

Leonard Cohen's favorite guitar was rumored to be a Godin Multiac with nylon strings. In the 1960s and 1970s he played a Ramirez flamenco guitar. Cohen's music always embraced gypsy culture and the romance of flamenco.

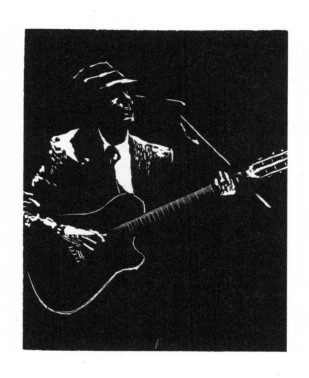

I like a nice hat and so did Leonard Cohen. He stopped wearing a fedora after 9/11 but started again on his last concert tour in 2012. It was a prop in his performances, taking it off to show respect and admiration to his fellow musicians. In 2008 he told *Maclean's* magazine, "I've been wearing a fedora for a long, long time. This particular hat is from a little hat store just opposite my daughter's antique store in Los Angeles. They have a very good hat store there."

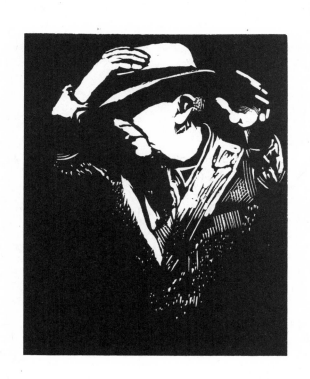

Leonard Cohen took his backup singers, Charley Webb (b. 1979), Hattie Webb (b. 1981) and Sharon Robinson on his *Old Ideas World Tour* in 2012. My wife and I caught the show in London, Ontario in 2012.

Leonard Cohen surrounded by his interlocking hearts design that referenced the Star of David. Cohen wrote in an email, "Somewhere in my notebooks from the early eighties there is my own first crude sketch, two hearts, one on the other, one up, one down, but not interlocking. The interlocking, common to renditions of The Star of David, was drawn by an artist at McClelland & Stewart, my Canadian publisher." The original image first appeared on the cover of *Book of Mercy* in 1984. Some have suggested that Cohen's Order of the Unified Heart, is the symbol of his fans and friends. Jarkko Arjatsalo, whom Cohen calls "the General Secretary of the party," is the founder and administrator of the website: leonardcohenfiles.com, to which Cohen was a frequent contributor.

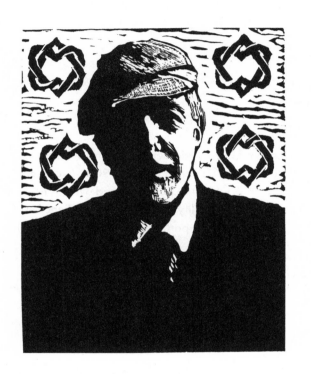

Leonard Cohen released his final record album, *You Want It Darker,* in October, 2016. In concert Cohen would often place his hand over his heart as a sign of humility and love for his audience as well as his fellow performers.

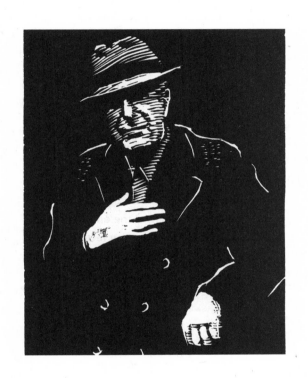

Leonard Cohen promised himself he would take up smoking again on his eightieth birthday. He could finally live it up and stop worrying about shortening his life with bad habits. True pleasure is knowing that, at the end of the day, you can die with a smile on your face.

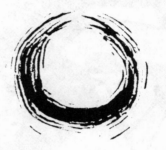

# LEONARD COHEN
## TAMING THE WILD OX
### TOM SMART

The state of enlightenment for which Zen aims is a form of conscious-ness that comes from the simple yet profound understanding of the self. The path to such insight is progressive. The metaphor of walking is frequently used to express the steps one takes to achieve enlight-ment, even if only briefly.

Viewing that path at the end of a journey can be instructive in con-veying meaning about the nature of the walk, the significance of the episodes encountered while on it and the quality of the walker's char-acter. The journey as a metaphor of a life is a convenient and helpful way to give the seemingly aimless directions one takes over a lifetime some coherence and order. We all crave structure and purpose. With-out these we face the frightening prospect that existence is just an ac-cumulation of random, arbitrary episodes and decisions without mean-ing or purpose.

Poetry and myth are two means by which we organize life. In the hands of an artist, biography can arrange and shape events to provide sense, a narrative arc and a grand cadence to the inchoate mosaic of episodes that, when read together, comprise the story of a life and give it meaning.

Leonard Cohen's life-long walk ended on November 7, 2016. On his complicated journey, his holy trek, he never lost faith in a prayer-ful truth that "nothing gets me high and offers relief from suffering like blackening pages, writing." If his life were a book, the light from the pages' paper would have long been extinguished by the weight of ink laid down on the pulpy grounds, white pages blackened by his sonorous words and silent graphic images.

Leonard Cohen's lyrics and poems equip many people with significant images and words that help them organize their own lives. They also supply moral lessons, perhaps even explaining why a particular individual's path twisted and turned as they did over time.

George A. Walker's woodcut narrative is, similarly, a pictorial interpretation and lens through which you can glimpse many real and imagined episodes that have taken place over the course of Cohen's lifetime. Walker's is a commentary and a visual exegesis on the poet's progress from youth to old age. Cohen travelled through a mythical landscape populated by lovers, poets, musicians and other characters of the music industry at times defined by excess.

No matter the stage, or even the landscape, this book, like the words, lyrics, and music of its protagonist, maps the progressive steps of awareness that leads closer and closer to the instant of enlightenment.

Cohen absorbed and manifested the simple Zen principle that enlightenment comes from the self.

A book, our mythic guide to understanding Cohen's life, is one composed in the twelfth century by the Chinese master Kakuan, who drew ten pictures of a wild bull ox and a pilgrim wanderer who tamed it. Over the centuries, many editions of the book were also translated as wood engravings. The verses that accompanied the pictures became inspiring Zen lessons. The fable of the pilgrim and the bull – *Ten Bulls* – teaches how purity might be achieved over the course of a life's journey by reflecting on the meaning of the pathway, the character and nature of the bull and how, in domesticating it, enlightenment can be gained.

*Ten Bulls* has been a continual source of inspiration to students of Zen from the earliest times. The allegory may well also have affected Cohen, particularly in his own experiences as a Zen monk. Picture and poetic commentary, this elemental storytelling convention usually seen in emblem poetry, comprises the basic format of this humble book. The sequence of ten pictures and their written commentaries rise above just poetry and pictorial narrative. Their meanings are reve-

latory, telling of how spiritual truths can be gained by confronting the essential dual nature of the human being, a paradox symbolized as the confrontation between the walking pilgrim and the bull.

*Ten Bulls* is about how the receptive, attentive individual can embrace his or her potential self and thereby fulfill their destiny. In other words: become pure by achieving a state of peace. But the journey, as described by the Zen master, is arduous, fraught with confusion and unknowing. The search for the elusive bull, we come to realize, is not even a search at all because the animal is not lost. It is a symbolic expression of true nature; the bull is a possession we all have as a birthright. As the pictorial narrative unfolds, the reader watches the pilgrim track down the beast, which he encounters resting, half- hidden along the shore of a river. Catching it, the pilgrim engages in a terrific struggle until the exhausted animal finally succumbs to the pilgrim's control. The pilgrim rides the tamed bull home.

Reaching home, the pilgrim becomes serene, blissfully calm and seemingly at one with what he sees and senses. In this state, he transcends the bull and his self and eventually arrives at a state of pure essence, where there is no separation between soul and flesh. When he comes down from this altered state, he once again walks among his fellow villagers in the marketplace and, to his astonishment, discovers that everyone he looks upon becomes enlightened.

Of the many themes this fable treats – the journey toward understanding; the synthesis of the dual nature of the human being's soul and form; the experience of oneness; the purity of grace – the final lesson is that, for the pilgrim, the world looked different after his encounter with the bull. A spiritual lesson on confronting and cultivating our primal nature, *Ten Bulls* also points to a truthful life's lesson, perhaps learned late in life when looking back at the paths walked and the trials along the way. The bull and all that it symbolizes is within us.

That is what the Zen story is about. For us, while reading Walker's pictorial biography of Cohen, it can serve as an object lesson in finding coherence and meaning in the protagonist's life. Cohen's biographical cadence follows a similar arc to the Zen pilgrim's. It traces a path toward enlightenment.

More than a simple spiritual lesson, the ten-page book is a concise allegory about the manner in which art has the capacity to change the way the world is perceived after a journey through which we come to terms with our primal selves, symbolized as a bull. In this woodcut narrative, Walker tells us that Cohen's words, lyrics, and songs can be guideposts that order the disparate experiences comprising a fully lived life. Cohen's art and the metaphors he uses can give coherence and meaning to the attentive listener and reader, perhaps even enabling us to bring our own bulls under control. Similarly, Walker's prints organize episodes in a biographical mosaic, suggesting a narrative that can be constructed from the seeming random chaos of a life lived as an artist.

The human mind is a kind of wild ox bull. The Zen master, the poet, the artist, the graphic novelist, all can impart wisdom, means, and materials to tame its primal nature. Art allows the patient, attentive student to change their perceptions of reality and their places in it. Cohen's journey over the course of his life, described in these wood engravings, can be a chart to guide us as we struggle on our own long walks to achieve our true natures.

—February 2020

**TOM SMART** is a curator, essayist and art gallery director. He is an award-winning author of biographies, catalogues and art books on Canadian artists such as painters Christopher Pratt, Jack Chambers, Alex Colville, Mary Pratt, Tom Forrestall, Miller Brittain and Fred Ross; graphic novelists George A. Walker and Seth; sculptor John Hooper and many other contemporary and historical artists.

Currently the Executive Director and CEO of the Beaverbrook Art Gallery, Smart has worked in art galleries and museums across Canada and the United States, among them the Frick in Pittsburgh, the Winnipeg Art Gallery and the McMichael Canadian Art Collection, where he was executive director from 2006 to 2010. Smart was a Distinguished Visiting Scholar at Pittsburgh's Carnegie Mellon University.

# ABOUT GEORGE A. WALKER

Photo: Michelle Walker

**George A. Walker** (Canadian, b. 1960) is an award-winning wood engraver, book artist, and author who has been creating artwork and books and publishing at his private press since 1984. Walker's popular courses in book arts and printmaking at OCAD University in Toronto, where he is Associate Professor, have been running continuously since 1985. For over twenty years Walker has exhibited his wood engravings and limited edition books internationally. Among many book projects, Walker has illustrated two hand-printed books written by internationally acclaimed author Neil Gaiman. Walker is also the illustrator of the first Canadian editions of Lewis Carroll's *Alice's Adventures In Wonderland*, *Alice Through the Looking-Glass* and the *Hunting of the Snark* (Cheshire Cat Press). George A. Walker was elected to the Royal Canadian Academy of Art for his contribution to the cultural area of Book Arts.

# ACKNOWLEDGEMENTS

The success of any book depends largely on the encouragement and help of many others, and I would like to express my gratitude to everyone who has assisted me. My greatest appreciation goes to my wife Michelle and to my kids, Nicholas and Dylan. I can't say thank you enough to my sister Janice and her husband Neil for their tremendous support, and to my studio assistant, Amelia Radford, for her great help and patience on this project. I am indebted to Tom Smart and Norm Ravvin, whose beautiful words enhance the experience of the art. My publisher of the Porcupine's Quill editions of my wordless narratives, Tim and Elke Inkster and Lionel Koffler at Firefly Books have provided ongoing support for my book projects. I also thank my friends and editors Dan Liebman and Michael Worek. Without all this encouragement and effort, this book would not have materialized.

# BIBLIOGRAPHY

Cohen, Leonard. *Beautiful Losers*. Toronto: McClelland & Stewart, 1991.

———. *Book of Longing*. Toronto: McClelland & Stewart, 2007.

———. *Book of Mercy*. Toronto: McClelland & Stewart, 2010.

———. *Dance Me to the End of Love*. New York: Welcome Books, 2006.

———. *Flowers for Hitler*. Toronto: McClelland & Stewart, 2018.

———. *Leonard Cohen Anthology*. New York: Amsco, 1991.

———. *Leonard Cohen on Leonard Cohen: Interviews and Encounters*, ed. by Jeff Burger. Chicago: Chicago Review Press, 2015.

———. *Let Us Compare Mythologies*. Toronto: McClelland & Stewart, 2006.

———. *Poems and Songs*, ed. by Robert Faggen. New York: Everyman's Library, 2011.

———. *Stranger Music: Selected Poems and Songs*. Toronto: McClelland & Stewart, 1994.

———. *The Favourite Game*. Toronto: McClelland & Stewart, 2000.

———. *The Flame: Poems Notebooks Lyrics Drawings*. Picador USA, 2019.

———. *The Spice-Box of Earth*. Toronto: McClelland & Stewart, 1964.

Evans, Mike. *Leonard Cohen: An Illustrated Record.* United Kingdom: Plexus Publishing Ltd, 2018.

Hesthamar, Kari. *So Long Marianne: A Love Story.* Spartacus, Norway, 2014.

Holt, Jason. *Leonard Cohen and Philosophy: Various Positions.* Chicago: Open Court 2014.

Irwin, Colin, and Mark Beaumont. *Leonard Cohen: Still the Man.* London: Flame Tree Publishing, 2015.

Kubernik, Harvey. *Leonard Cohen: Everybody Knows.* BackBeat Books Canada: Monti Publishing 2014.

Lerner, Eric. *Matters of Vital Interest: A Forty-Year Friendship with Leonard Cohen.* New York: Da Capo Press, 2018.

Liebovitz, Liel. *A Broken Hallelujah: Rock And Roll Redemption And The Life Of Leonard Cohen.* New York: WW Norton, 2015.

Light, Alan. *The Holy or the Broken: Leonard Cohen, Jeff Buckley, and the Unlikely Ascent of 'Hallelujah.'* New York: Atria Books, 2013.

Myokyo-ni. *Gentling the Bull: The Ten Bull Pictures, a Spiritual Journey.* The Zen Centre, 1980.

Rajneesh, Bhagwan Shree. *The Search: Bhagwan Shree Rajneesh Talks on the Ten Bulls of Zen.* Poona: Rajneesh Foundation Ltd, 1977.

Reps, Paul and Nyogen Senzaki. *Zen Flesh, Zen Bones: A Collection of Zen and Pre-Zen Writings.* New York: Anchor Books/Doubleday, 1961.

Simmons, Sylvie. *I'm Your Man: The Life of Leonard Cohen.* Toronto: McClelland & Stewart, 2018.

# ALSO BY GEORGE A. WALKER

**Title:** The Woodcut Artist's Handbook:
　　　Techniques and Tools for Relief Printmaking
**Format:** Paperback
**Size:** 184 pages, 9.5 X 6.25 X 0.63 in
**ISBN:** 13:9781554076352

"Walker's instruction is so clear and well organized that this
handbook is perfect for the beginner."
　　　　　　　　　　　　　　　　*—American Artist*

**Title:** Graphic Witness: Four Wordless Graphic
　　　Novels by Frans Masereel, Lynd Ward,
　　　Giacomo Patri and Laurence Hyde
**Format:** Paperback with flaps
**Size:** 424 pages, 7 x 10 x 1.375 in
**ISBN:** 13:978-1554072705

"If you care about graphic novels, you need this book."
　　　— *New York Times* best-selling author Neil Gaiman

**Title:** Written in Wood: Three Wordless Graphic
　　　Narratives
**Format:** Paperback with flaps
**Size:** 360 pages, 7 x 10 x 1 in
**ISBN:** 13:978-1770854321

"The delicacy and intelligence of George Walker's
printmaking seems to have come to us from a bygone age.
Fortunately, we have George with us now."
　　　　　　　　　　　　　　　　— Neil Gaiman

# COLOPHON

The body of this book is set in Caledonia, a typeface designed by W. A. Dwiggins (1880–1956) and in the sans serif typeface Kabel, designed by Rudolf Koch (1876–1934), was used for the captions and headers.

The designer and artist Frank Newfeld (b. 1928) is a friend of mine. He planned and illustrated the the first limited edition of Cohen's poetry book, *The Spice-Box of Earth* for McClelland and Stewart in 1961. In that edition you'll find he used the typeface Caledonia and his drawings remind me of the illustration style of W. A. Dwiggins. It is from these eminent gentlemen that I attribute my design and type sensibilities. I should also mention that Frank Newfeld gave me his lino-cutting tools, for which I am forever grateful.